How to Draw Kittens

In Simple Steps

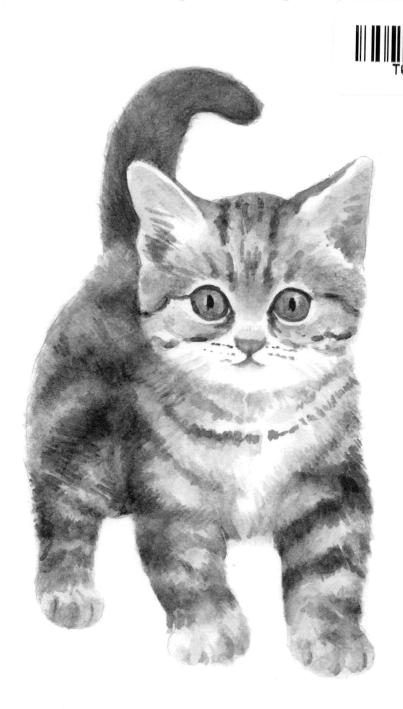

First published in 2023

Search Press Limited Wellwood, North Farm Road, Tunbridge Wells, Kent TN2 3DR

Text and illustrations copyright © Susie Hodge, 2023

Design copyright © Search Press Ltd. 2023

All rights reserved. No part of this book, text, photographs or illustrations may be reproduced or transmitted in any form or by any means by print, photoprint, microfilm, microfiche, photocopier, video, internet or in any way known or as yet unknown, or stored in a retrieval system, without written permission obtained beforehand from Search Press. Printed in China.

ISBN: 978-1-80092-108-5 ebook ISBN: 978-1-80093-099-5

Readers are permitted to reproduce any of the drawings or paintings in this book for their personal use, or for the purposes of selling for charity, free of charge and without the prior permission of the Publishers. Any use of the drawings or paintings for commercial purposes is not permitted without the prior permission of the Publishers.

Maine Coon 32

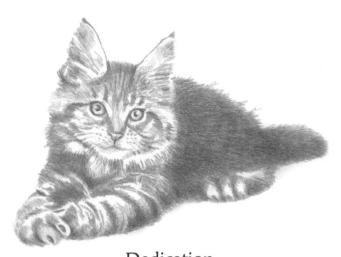

Dedication

To everyone who has ever rescued a cat or a kitten – thank you!

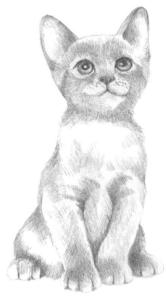

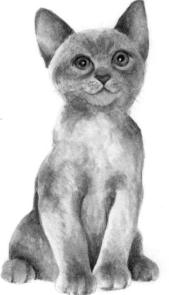

Illustrations

Cream Tabby Shorthair 5
Tabby and White 6
Domestic Medium Hair 7
Calico 8
Siamese 9
Ragamuffin 10
Domestic Shorthair 11
American Shorthair 12
British Shorthair 13
Orange/Ginger 14
Small Tabby 15
Russian Blue 16
Tabby and White Siberian cross 17
Tabby leaping 18

How to Draw Kittens

In Simple Steps
Susie Hodge

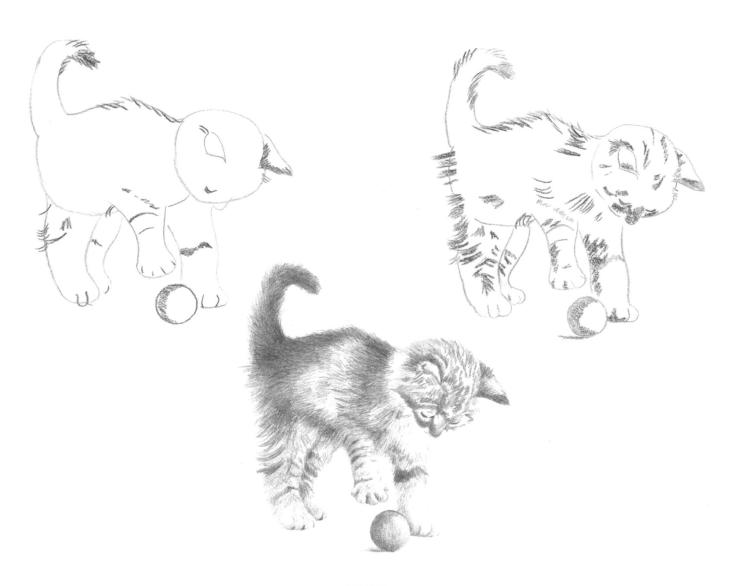

Introduction

Welcome to a book filled with drawings of kittens, showing their personalities and cuteness. They are fluffy, smooth, tabby and striped, and are shown sitting, standing, tails up or curled, relaxed or attentive. If you look at each drawing and follow the simple steps shown, you will soon be able to draw every one for yourself.

The aim of this book is to demystify the drawing process and to show that everything we see can be drawn using simple lines and shapes. Each kitten is drawn in the same way, starting with the most basic steps and continuing for five simple stages. The fifth drawing on each page is a finished, detailed drawing.

I have used two colours for the step-by-step process so you can see when each line or mark is added. In the first step, simple, initial shapes are drawn in red, summarizing the kitten's form. Step two shows the red lines from step one in blue, with new marks building the image in red. These show how to link the shapes into a more realistic kitten-like form or outline. In step three, all previous lines are now in blue and new red marks show where details are added such as paws, facial features and ears. In step four, further distinguishing elements including textures and tonal contrasts are added, and the fifth stage shows the completed drawing in graphite pencil. Everything is built up in light pencil marks, to show textures, tones, facial features and other details, which all help to convey the kitten's form and character.

When you follow these stages with your own drawings, there is no need to use coloured pencils, just a simple graphite one. Choose a fairly soft one, such as a B, 2B or a 3B. Keep it sharp and don't press hard, so that you can erase any mistakes along the way.

Finally, there is a watercolour of each kitten in its natural colours to give you further ideas of what you can do. If you're painting, draw a simple outline only and then use whatever materials you feel comfortable with, and let your paints, coloured pencils, pastels or whatever you use do the talking!

I hope you draw all the kittens in this book and then go on to draw more of your own. If you always use this simple construction method, you will attain the correct proportions. To do this from life, before you draw, look at the kitten and visualize its basic shapes and proportions – for instance, what is the size of the head compared to the body? Can you see the tail and how does it fall? Work out the length of the legs in relation to the length of the head and so on. You will soon become confident in drawing and will develop your own style, which I hope will give you years of pleasure.

Keep drawing!

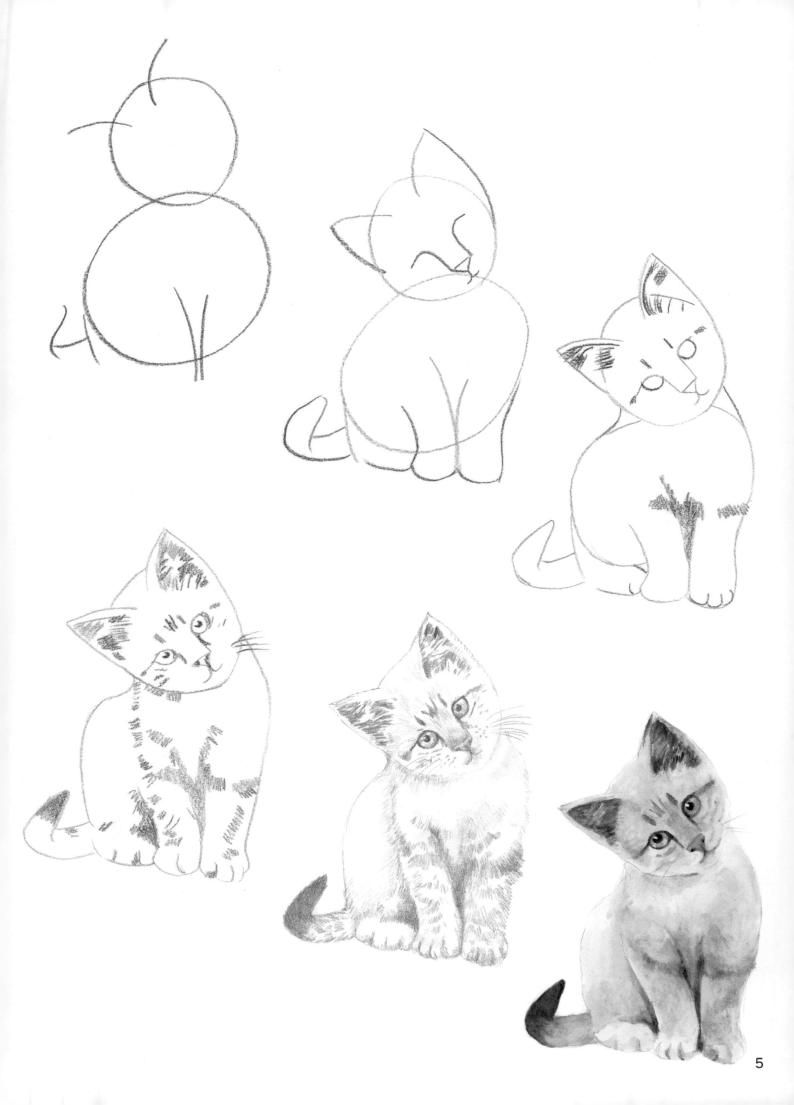

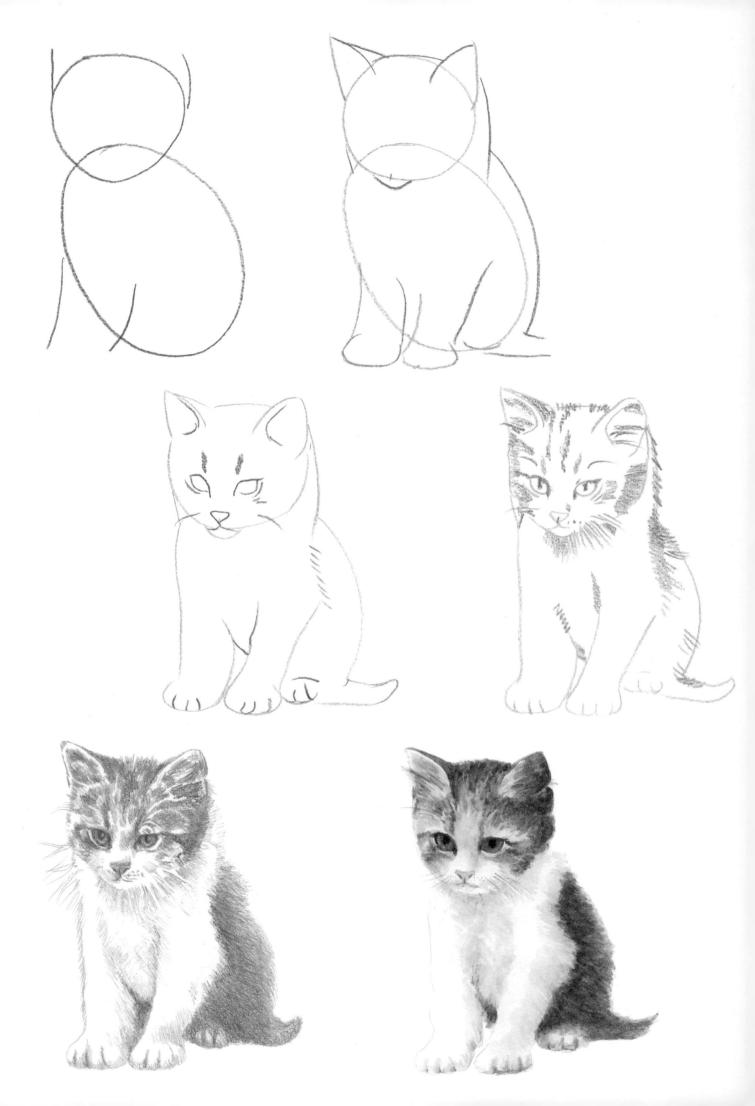

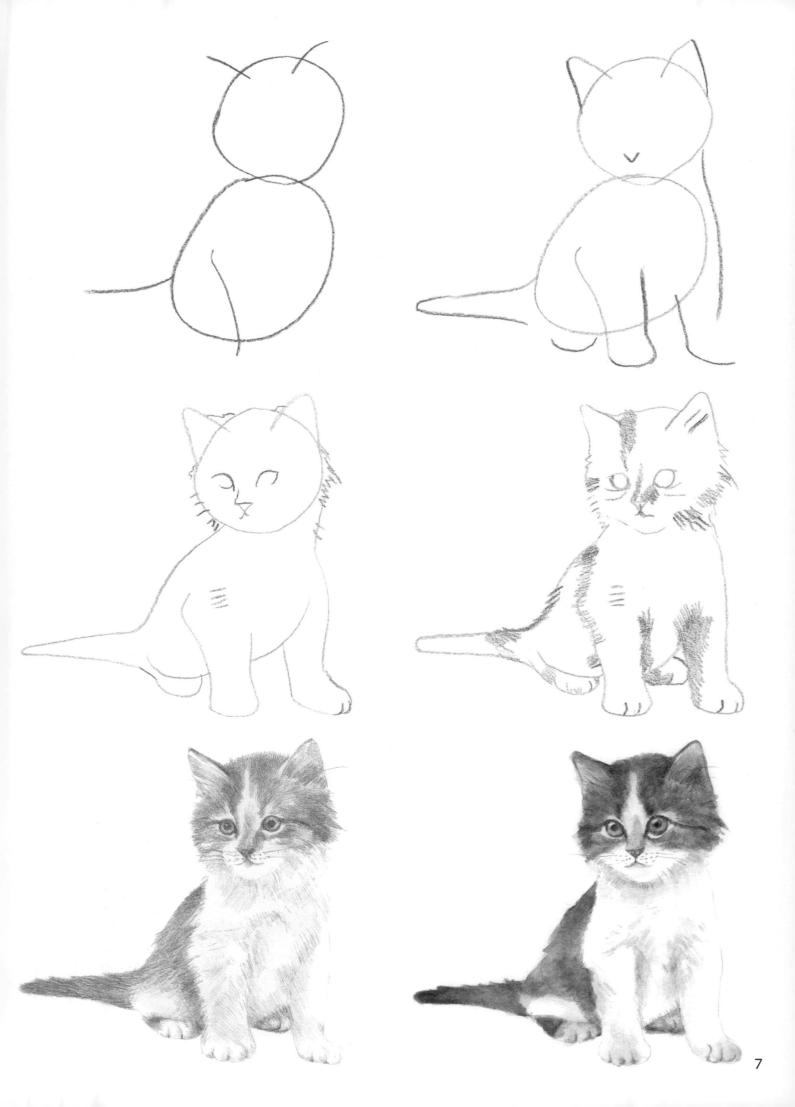

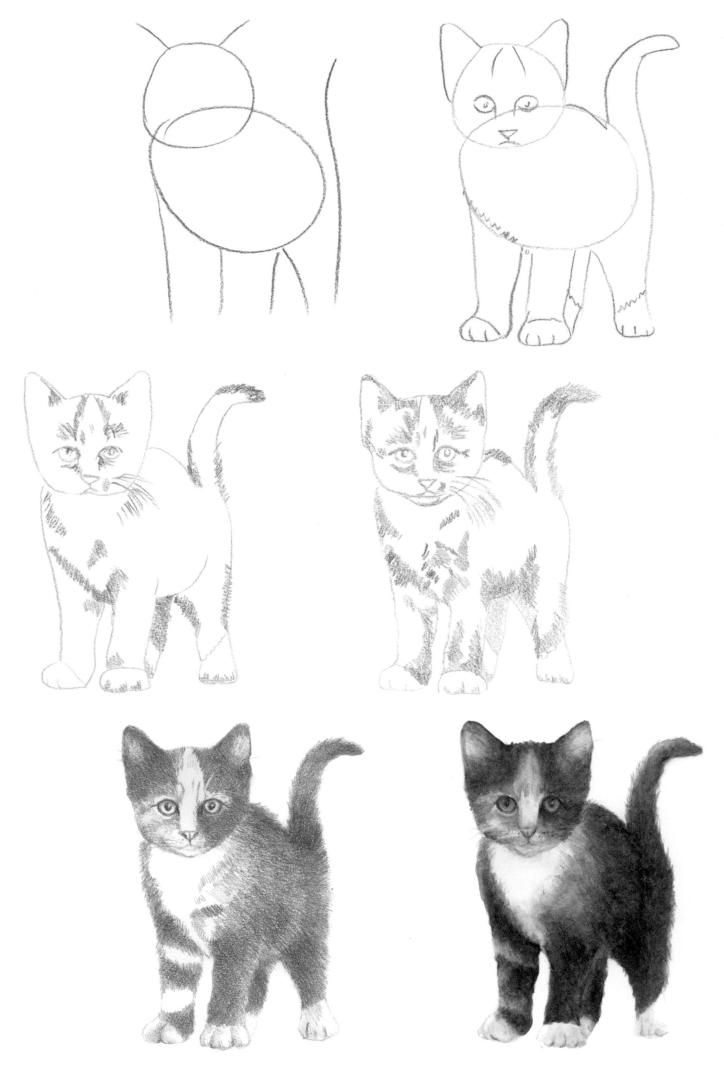

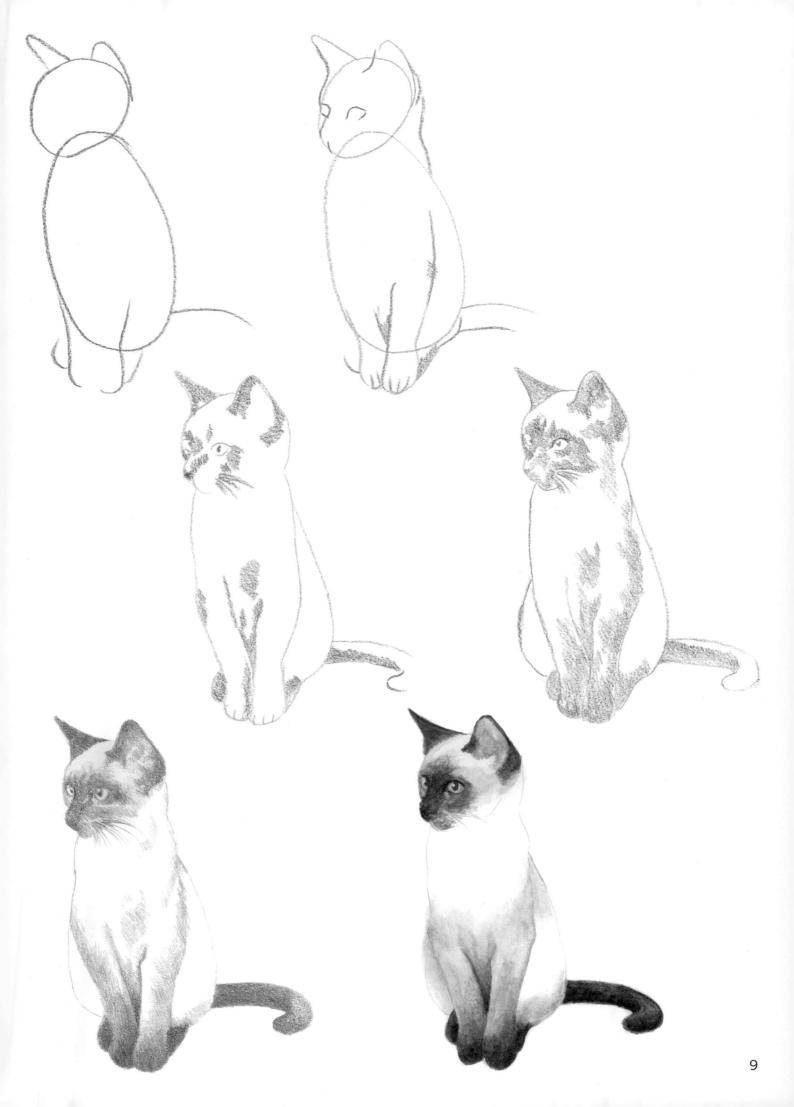

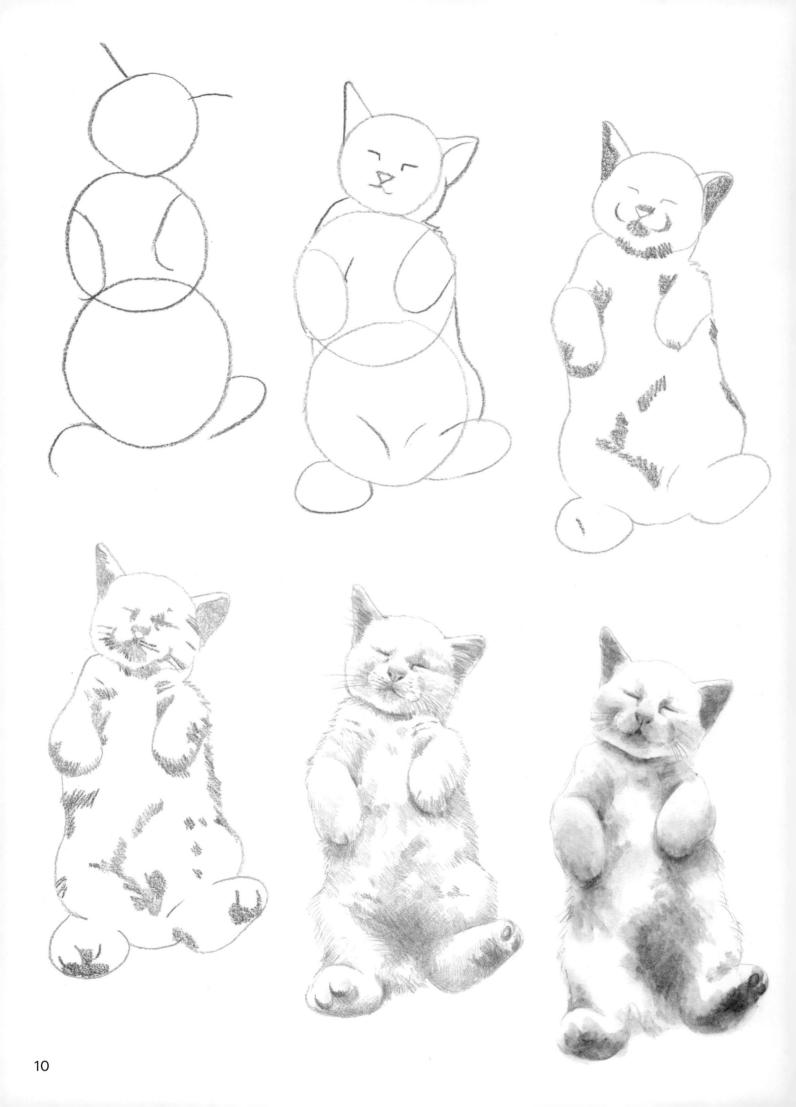

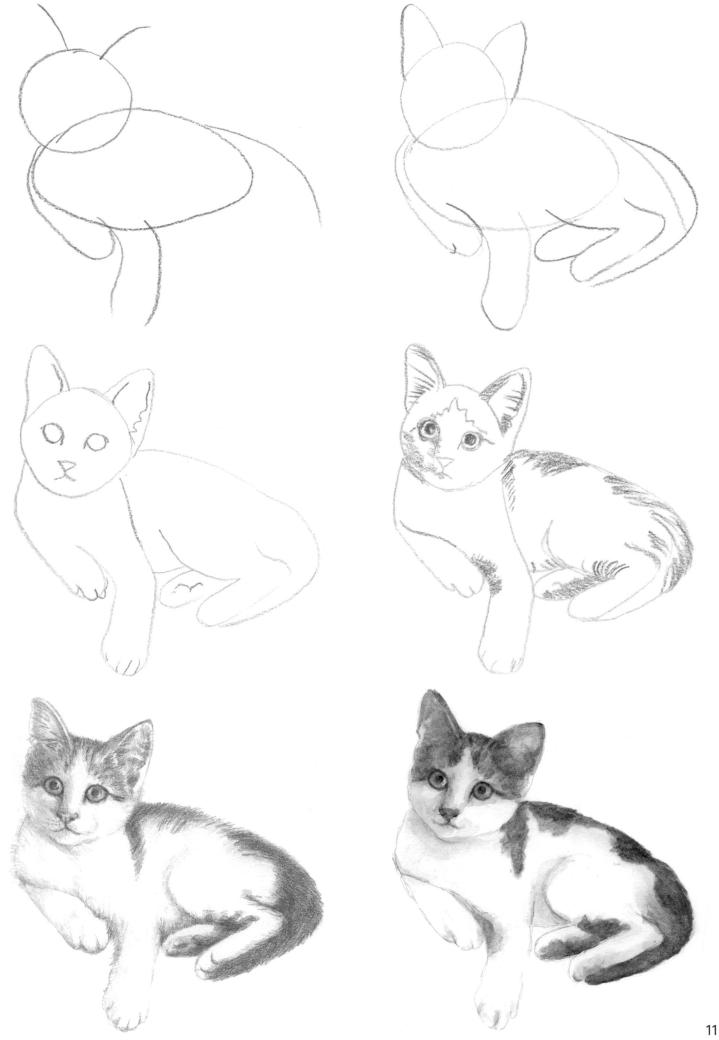

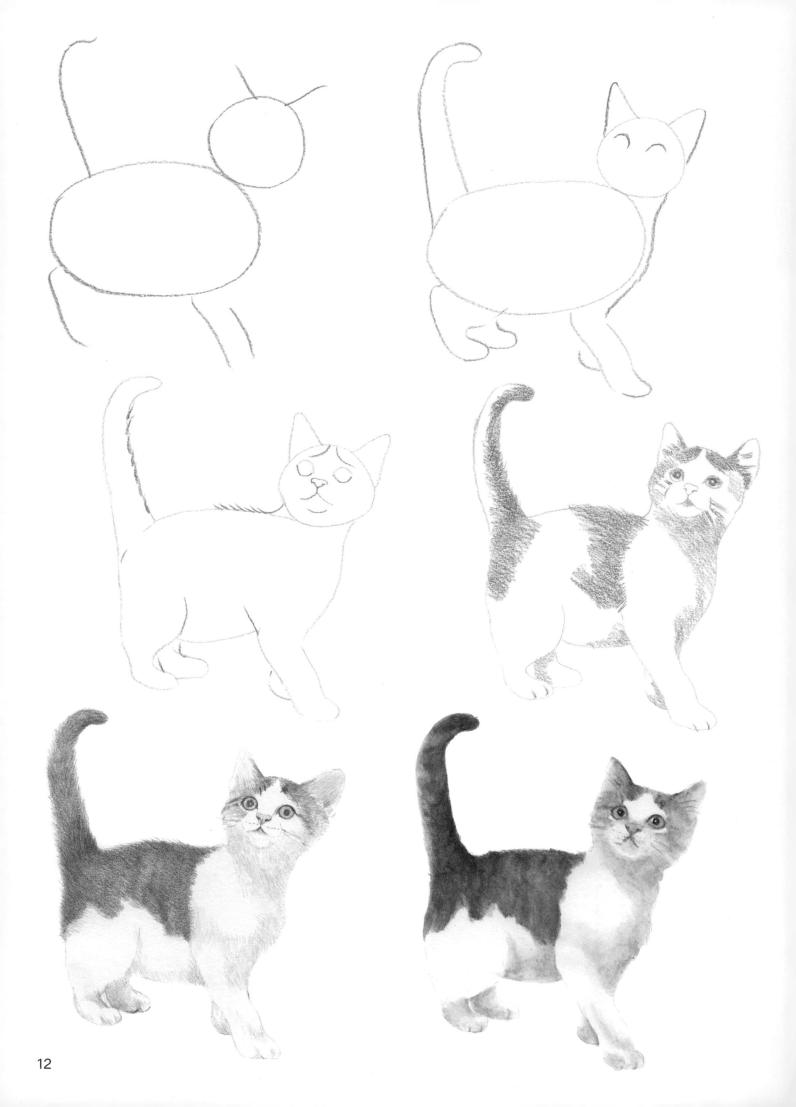

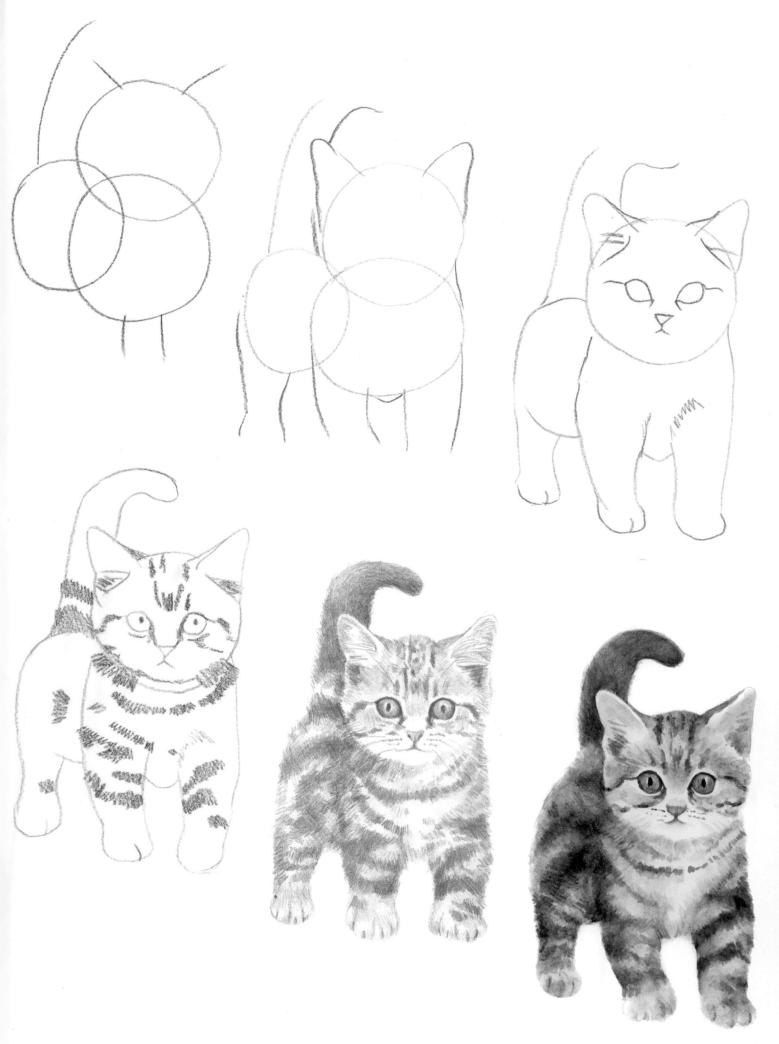

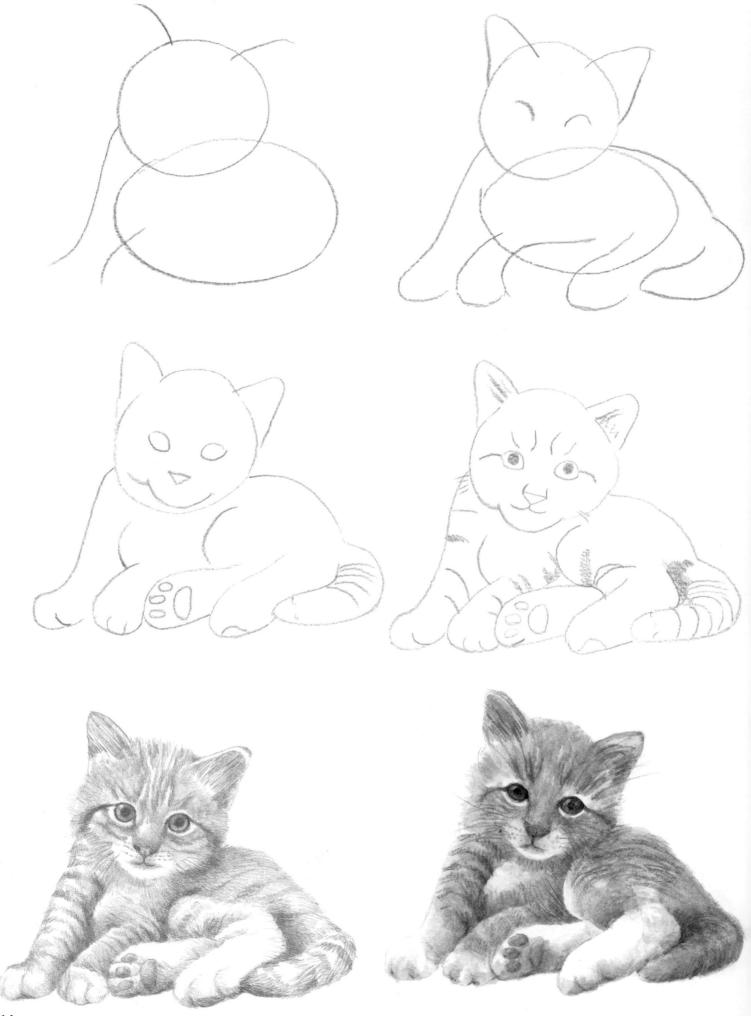

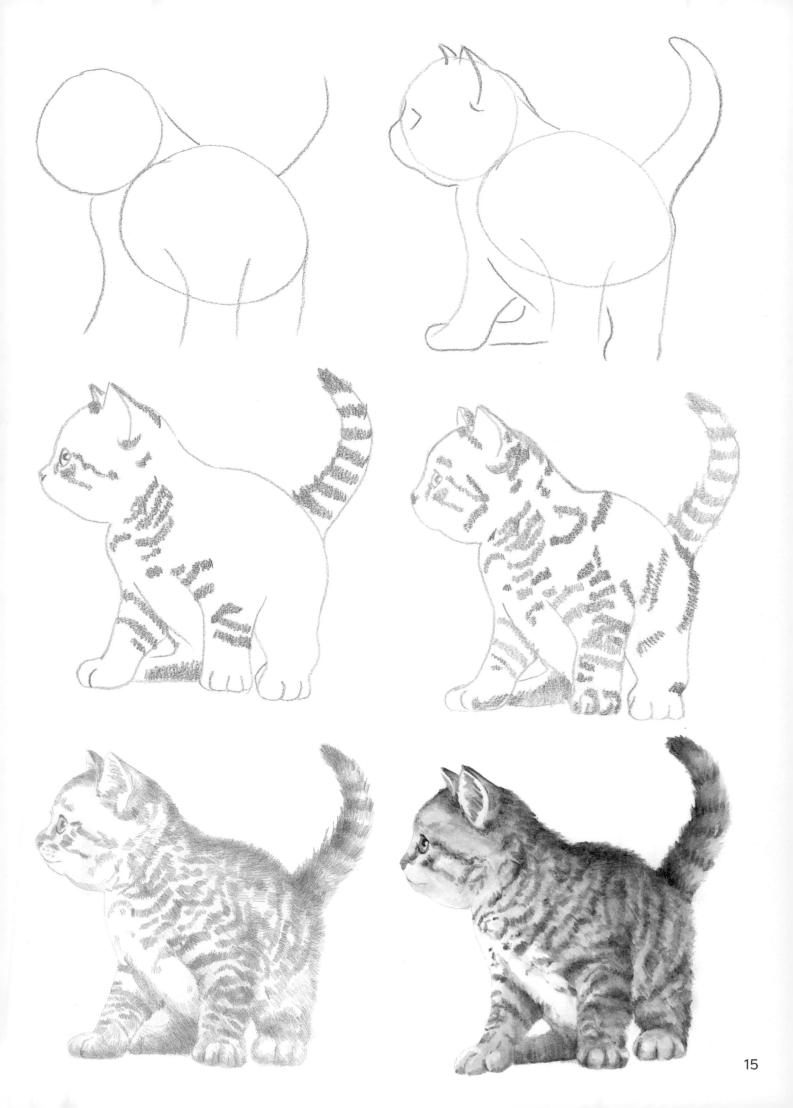

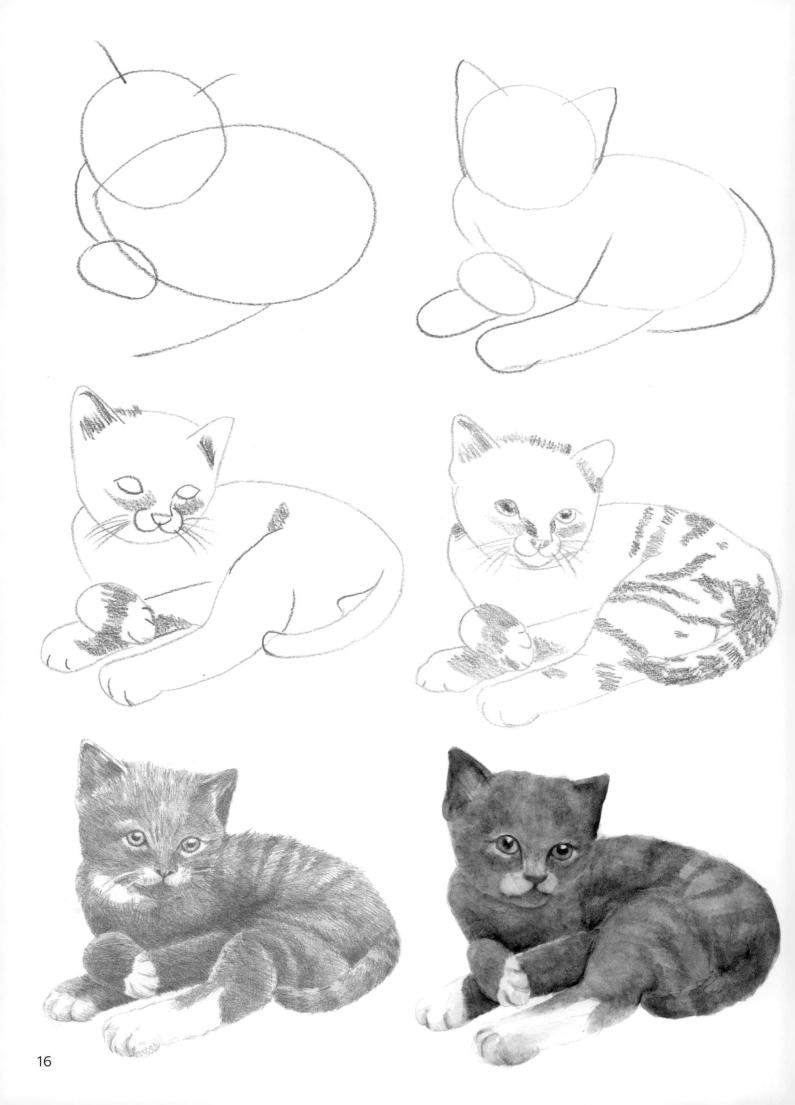

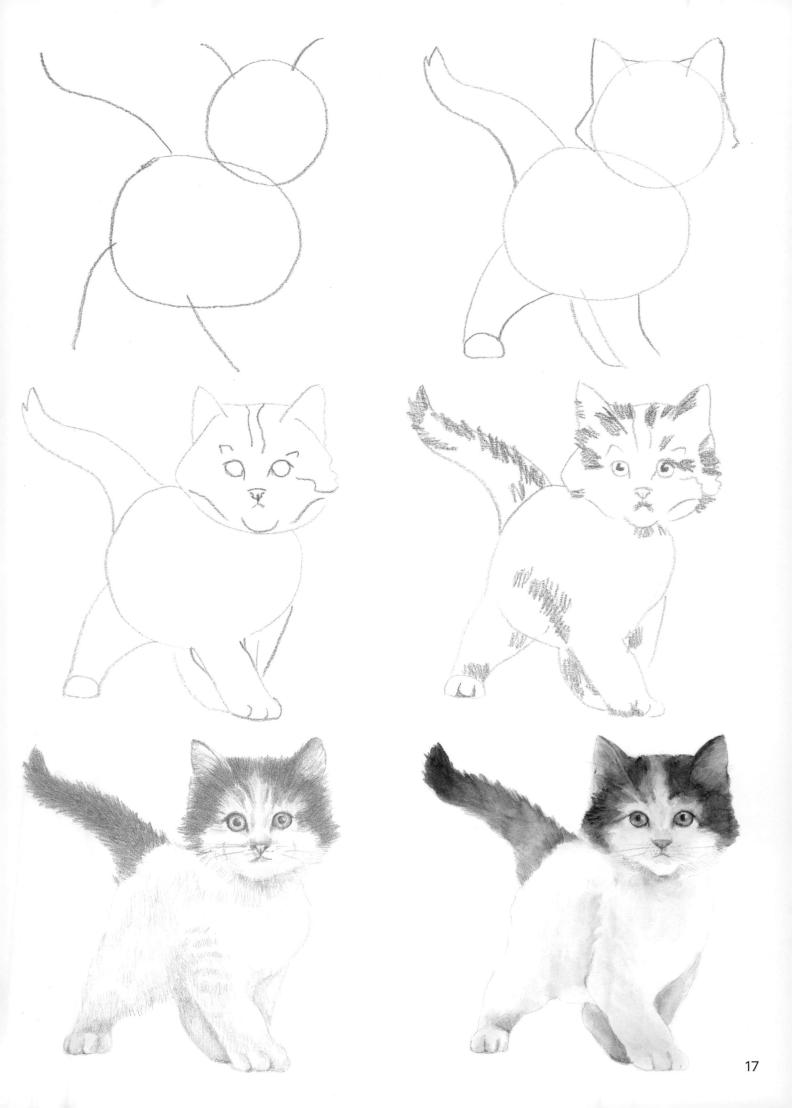

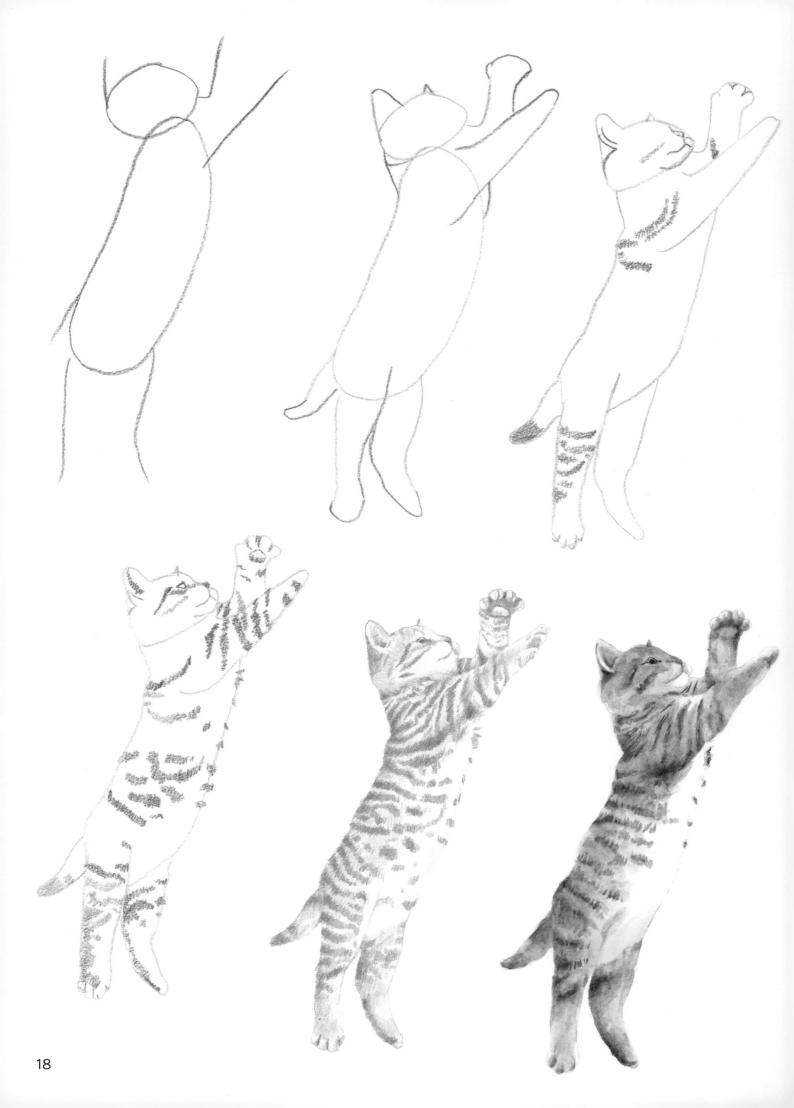

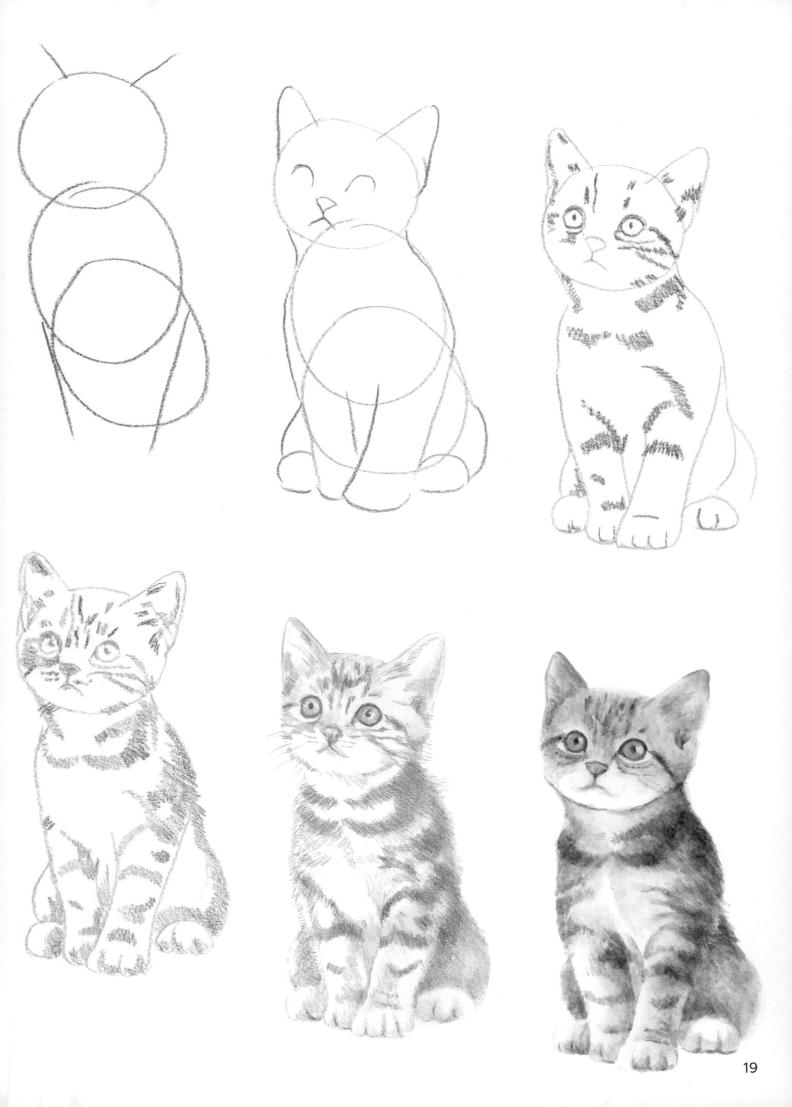

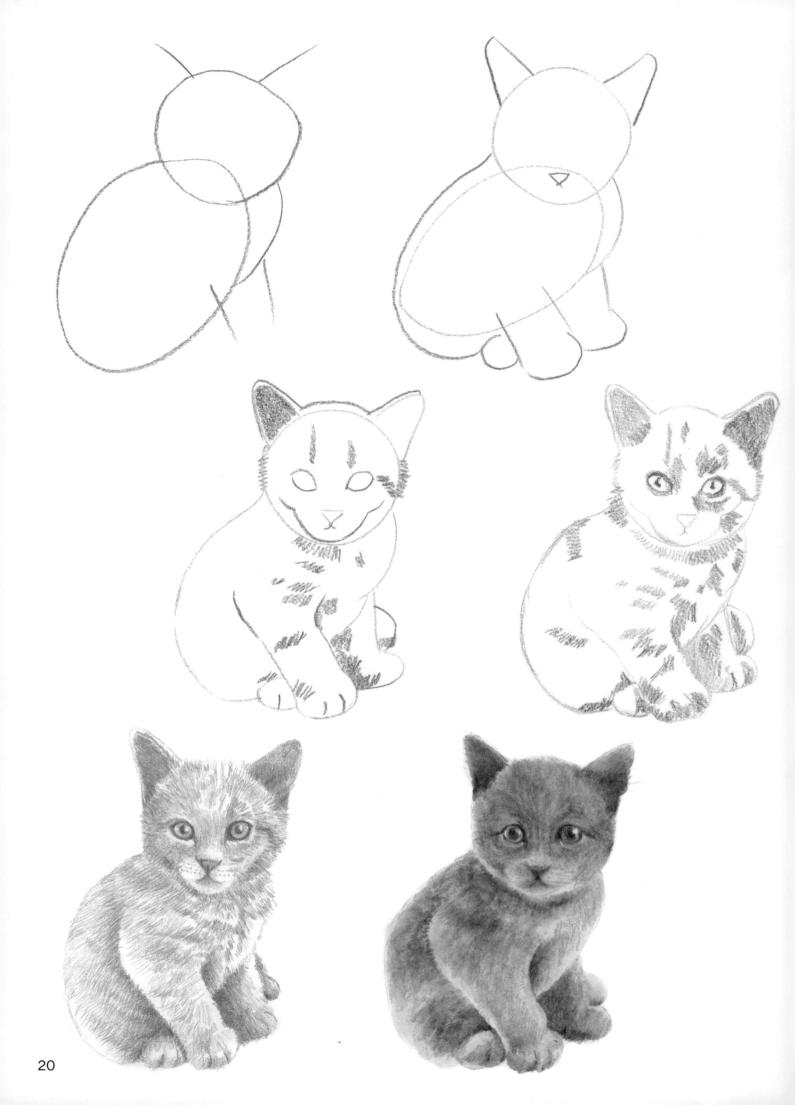

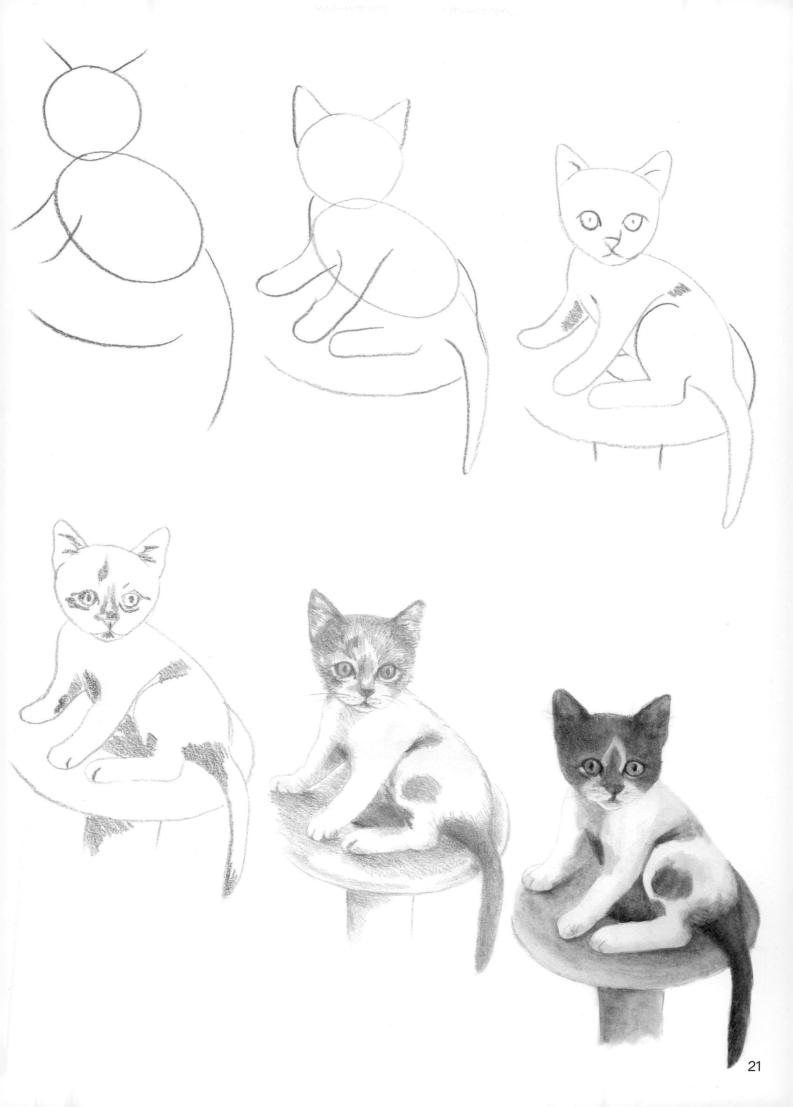

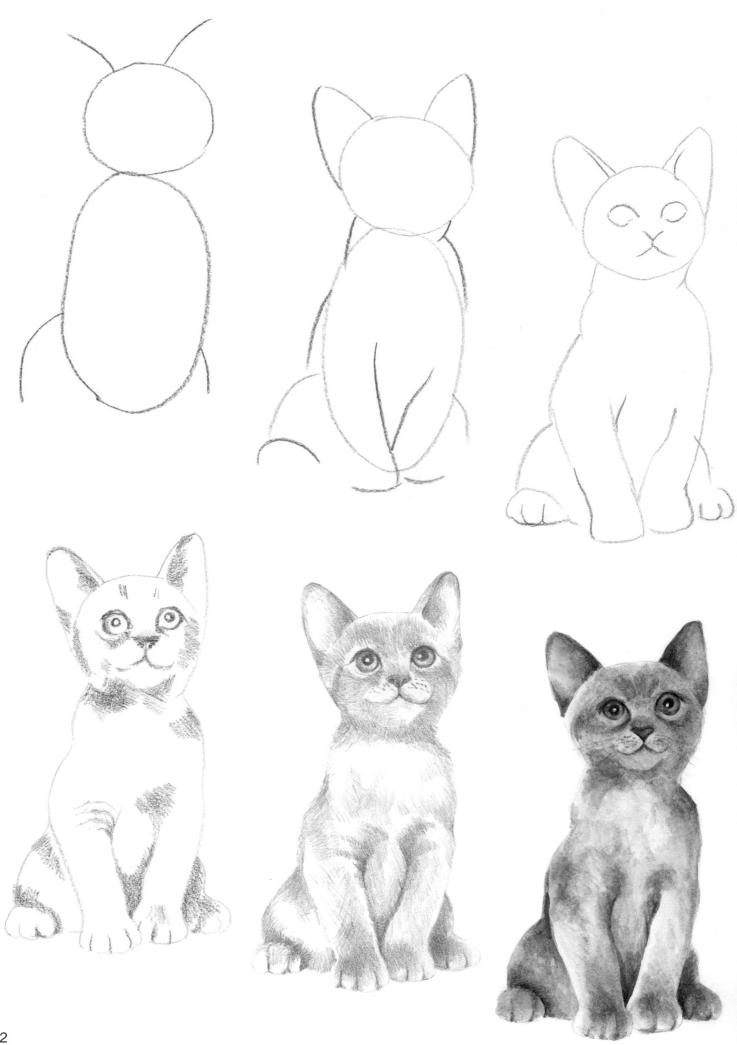

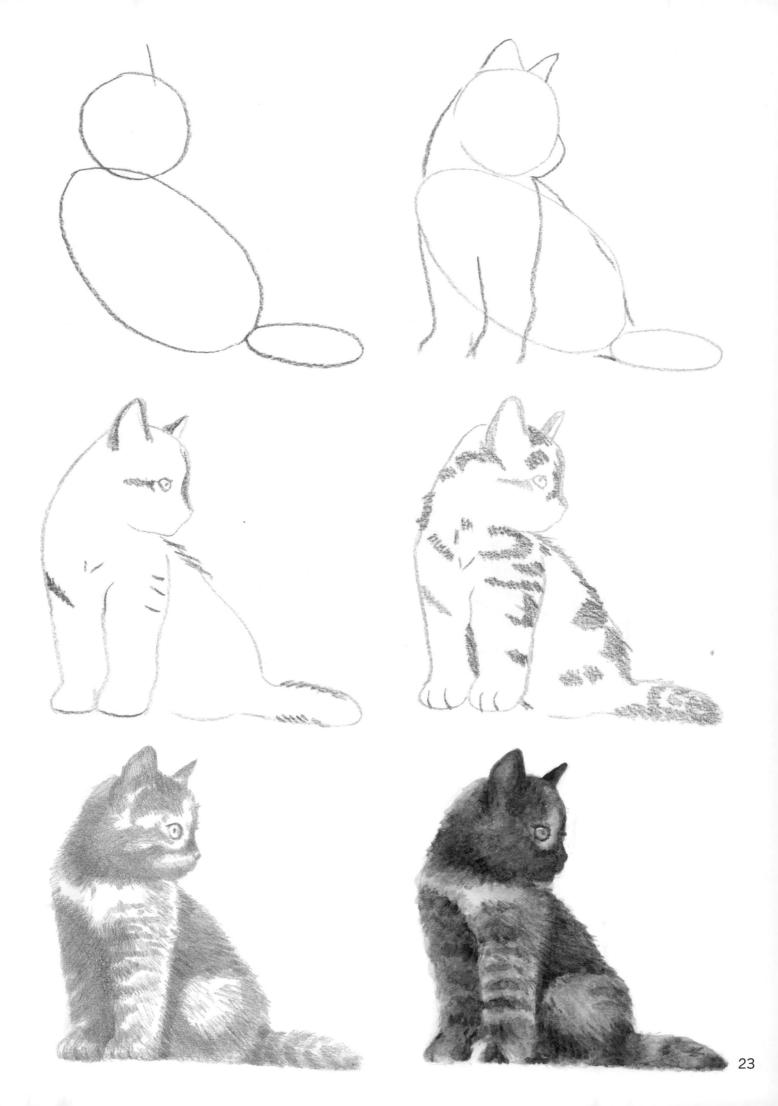

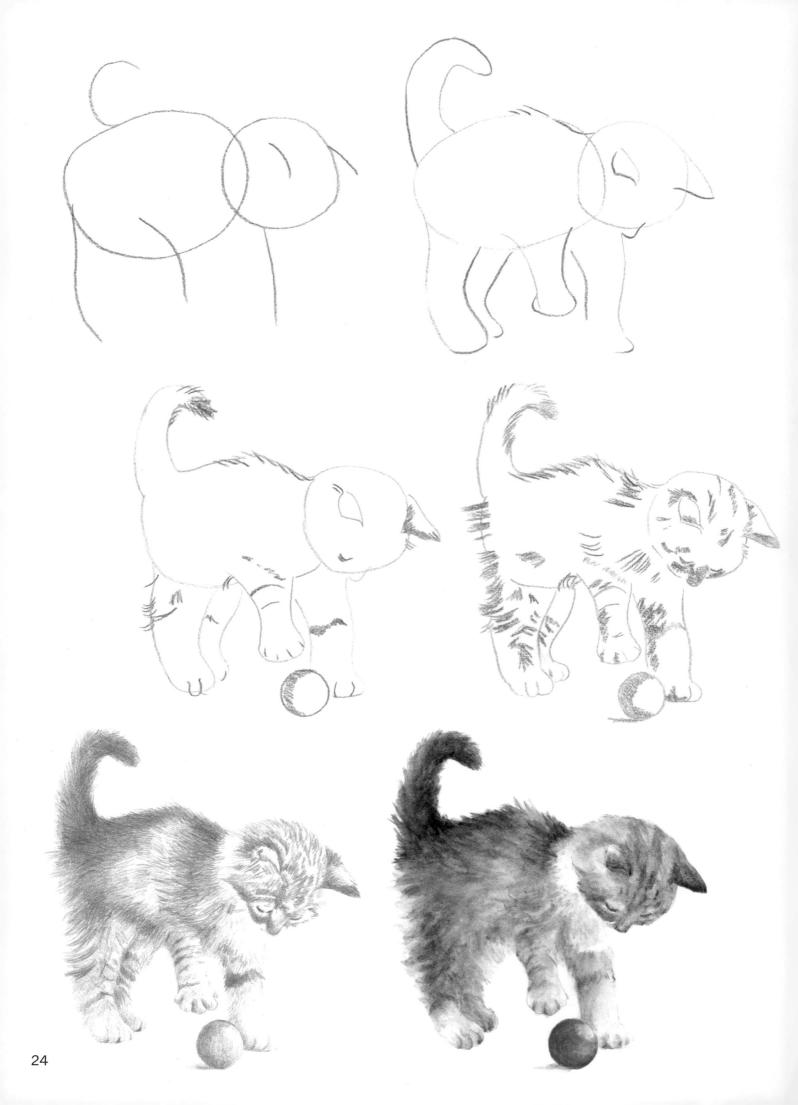

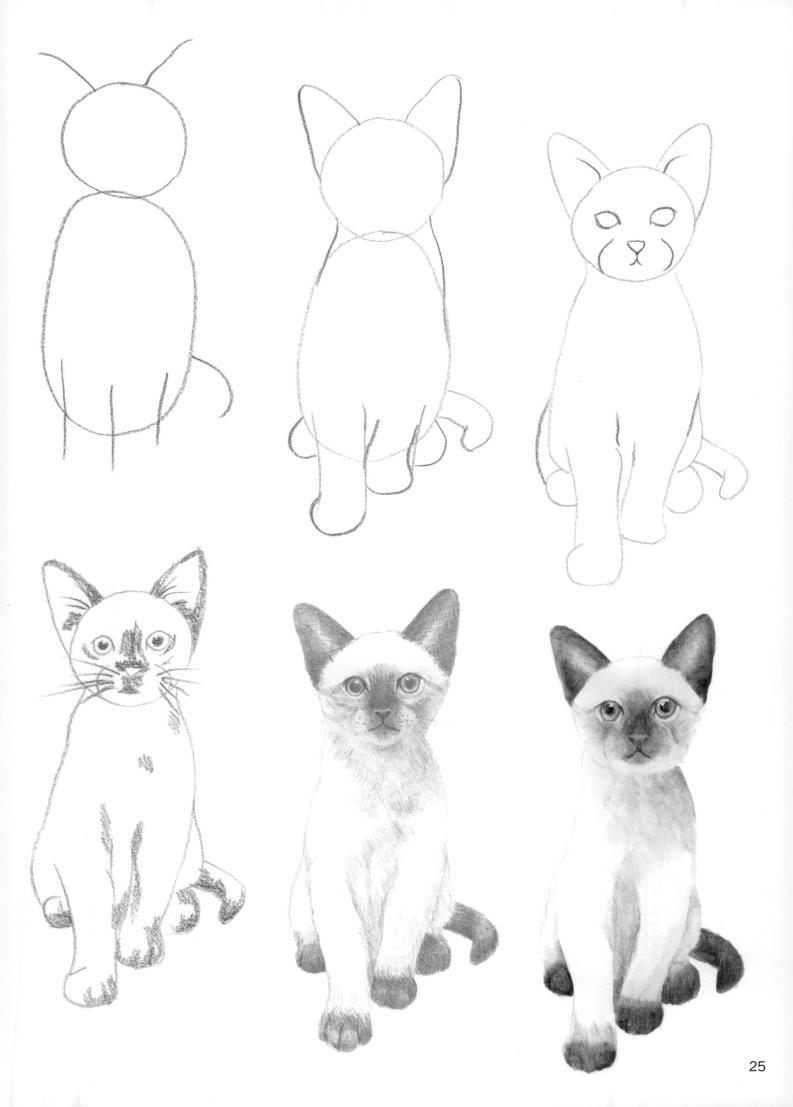

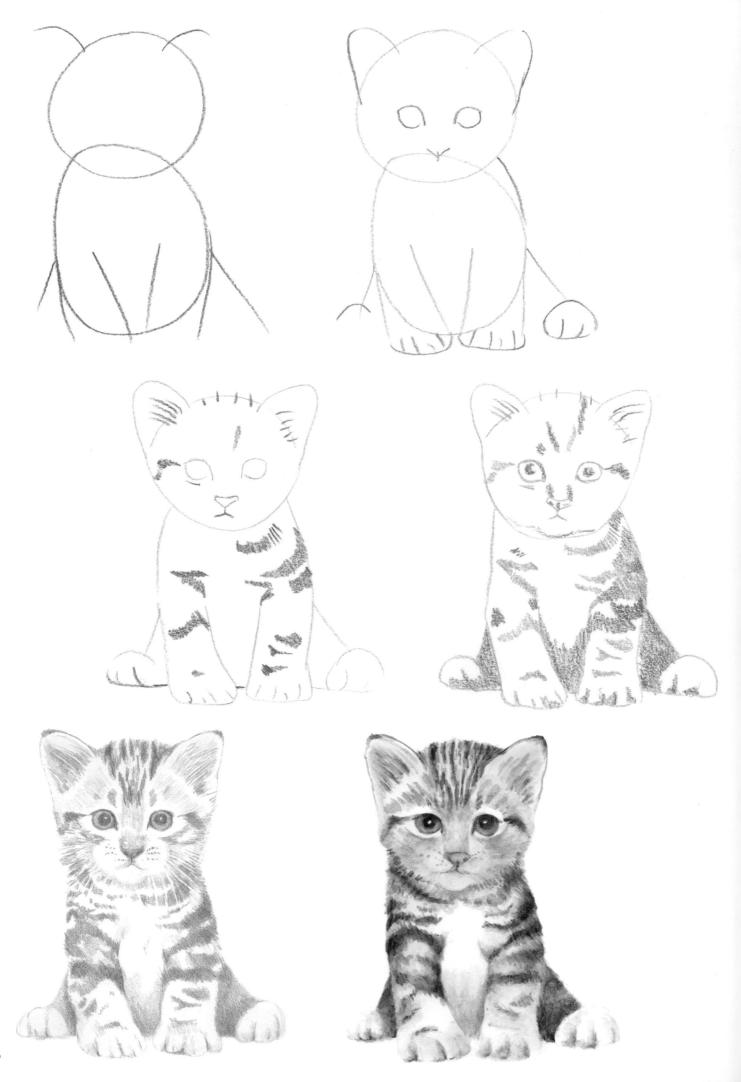

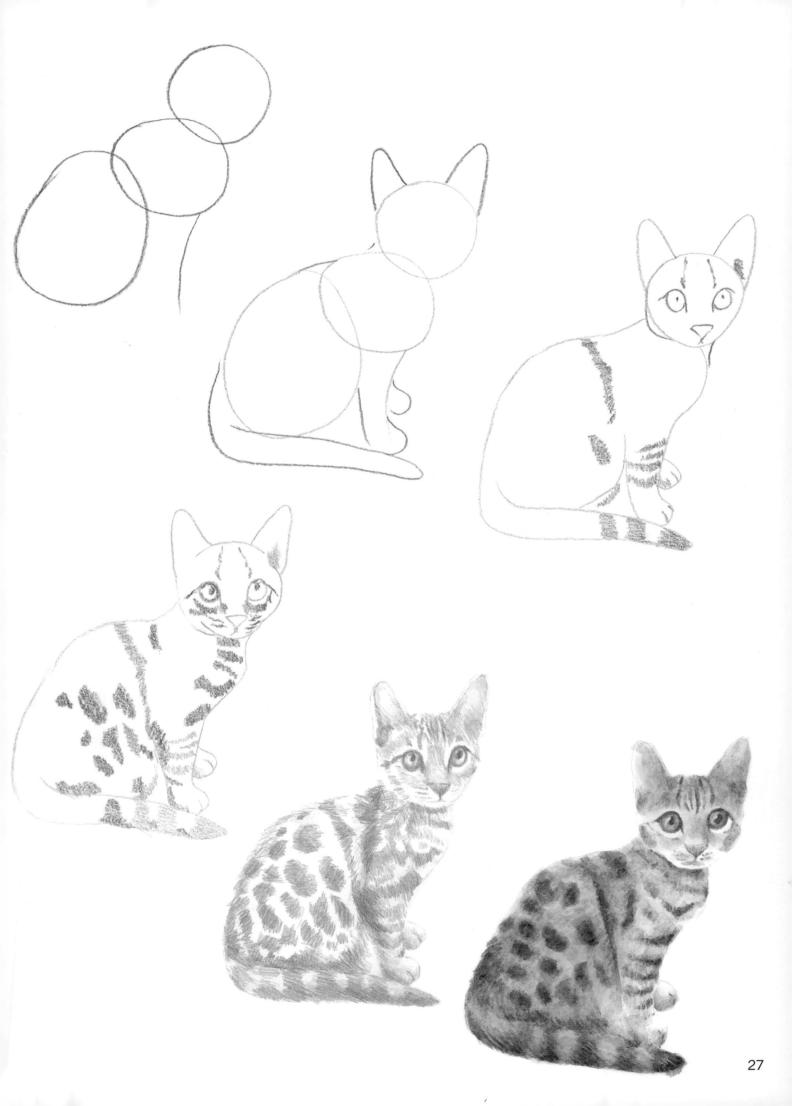

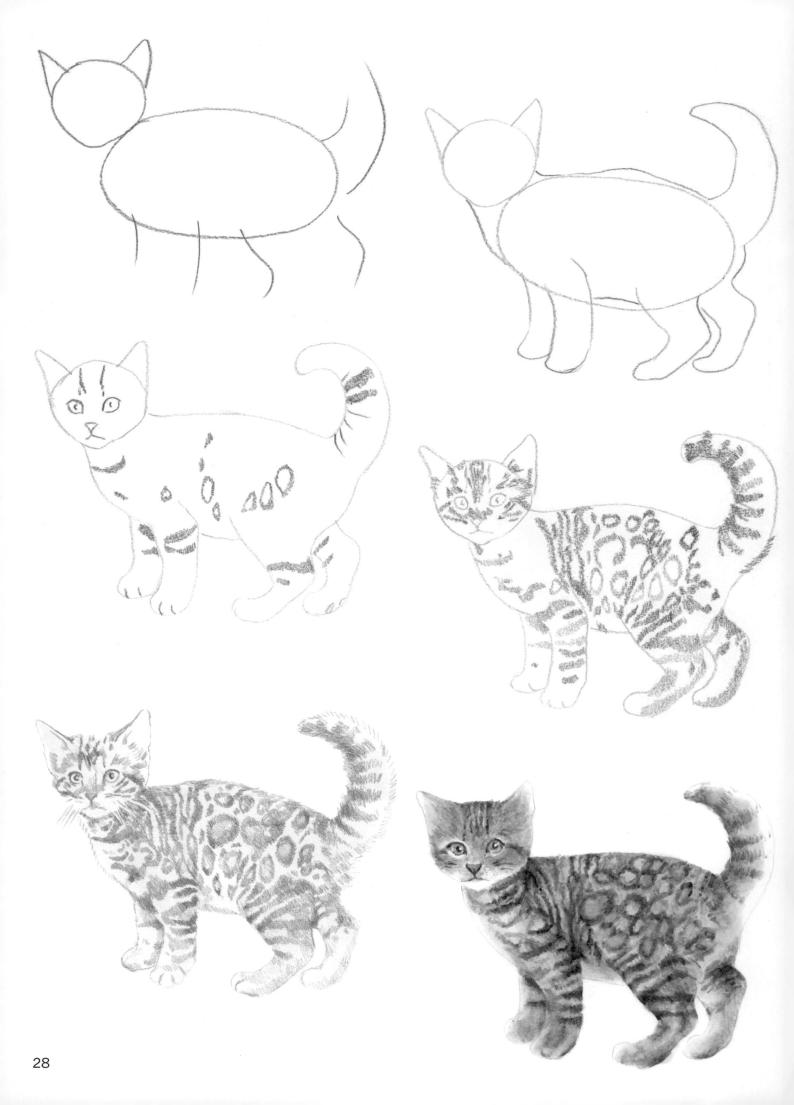

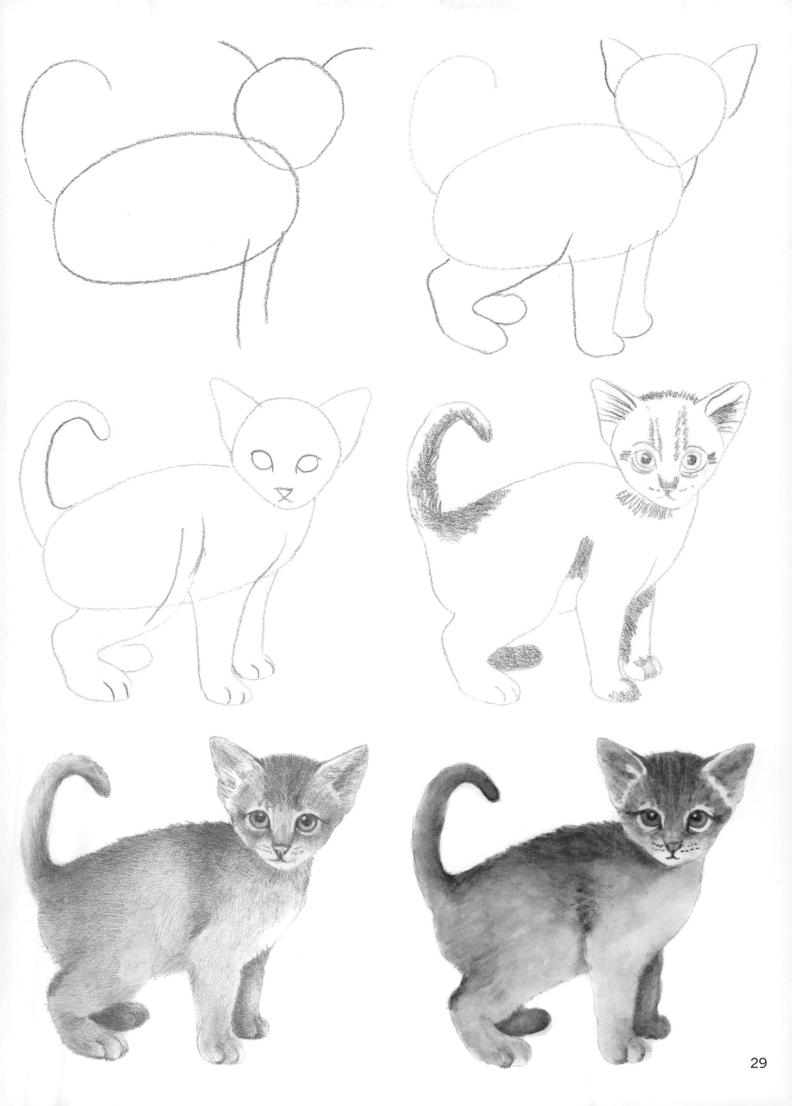

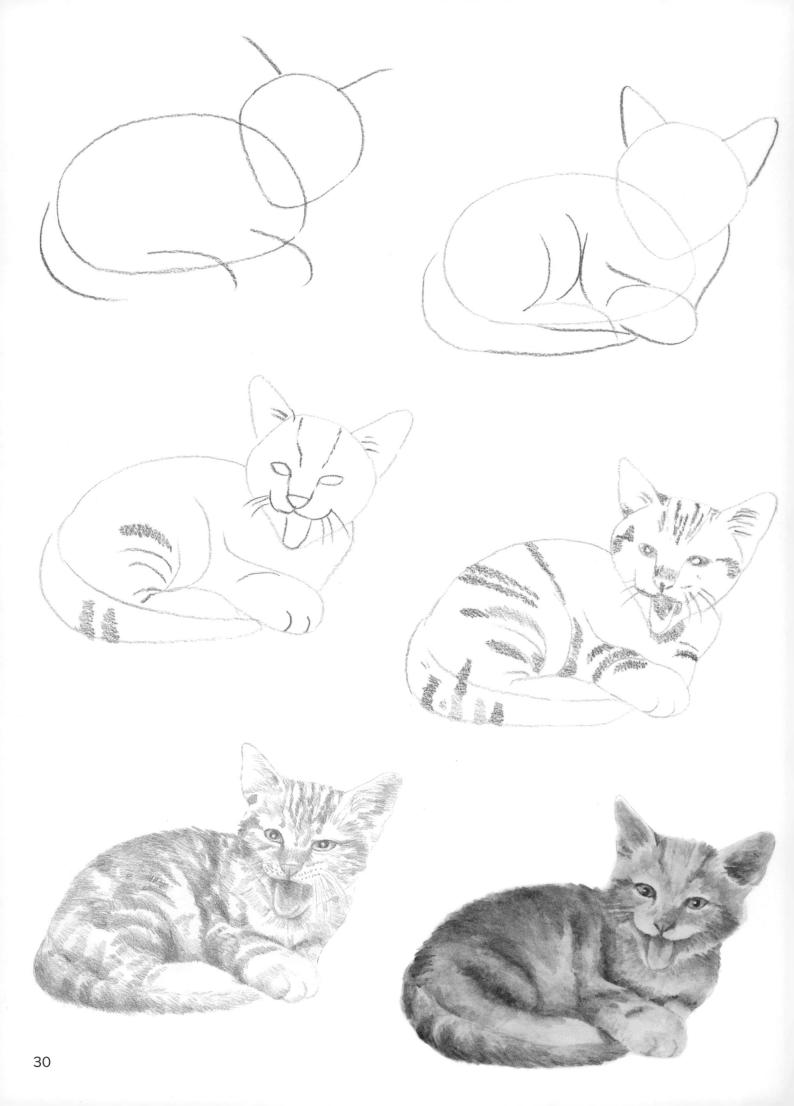

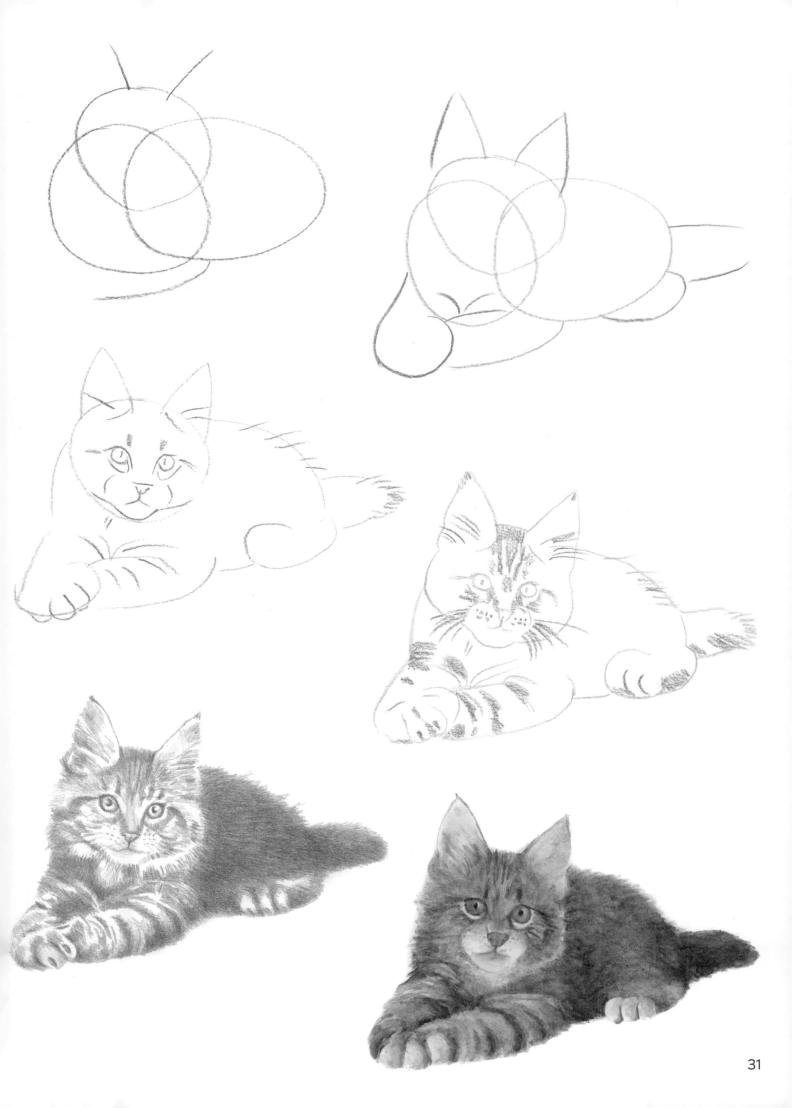

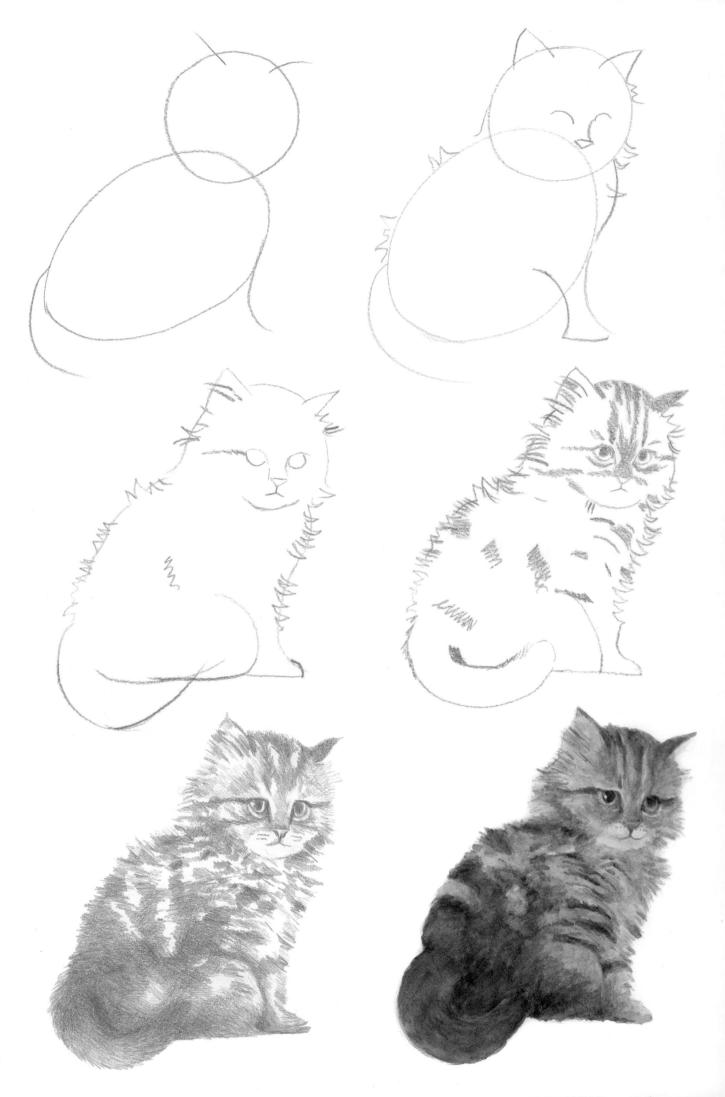